WELCOME to the fascinating world of origami! Here are some tips to keep in mind while folding:

▶ Pay careful attention to the dotted lines and arrows showing you which way to fold the paper.

▶ Always make sharp creases, using your fingernail, an ice cream stick, or ruler to help smooth the folds.

▶ Keep a supply of scrap paper handy to practice making an object. Feel free to label your paper to match the diagrams.

▶ When following each step, it helps to look at the next diagram to see what the result should look like.

▶ When making a fold with tapered points, start at the narrowest portion of the point and then crease upward or outward from there.

Have fun folding!

1. Make mountain folds, corner to corner, and valley folds, edge to edge.

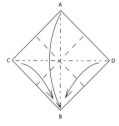

2. Mountain-fold the C and D corners, bringing A, C and D down to B.

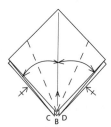

3. Your paper should look like this. Fold and unfold the bottom open edges to the crease. Repeat behind.

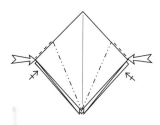

4. Push in the corners, following the creases from step three. Repeat behind.

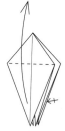

5. Fold up the front flap. Repeat behind.

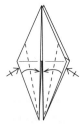

6. Fold in the bottom edges, two in the front and two in the back.

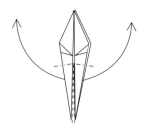

7. Inside-reverse-fold the bottom corners.

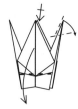

8. Inside-reverse-fold one corner for the beak. Fold down the wings.

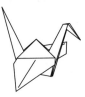

9. The finished Crane.

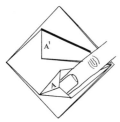

10. Squash-fold points A and A1. Repeat steps 8-10 on the back.

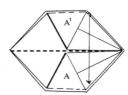

11. Valley-fold A1 to meet A. Repeat on the back.

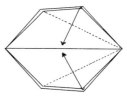

12. Valley-fold the first layer of the top and bottom points, bringing them to meet in the center as in a kite-fold. Repeat on the back.

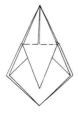

13. Rotate the shape so that the open points face to the top. Fold down the top point as far as it will go. Turn each layer of paper until the four points are folded down.

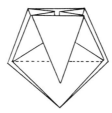

14. Your paper should look like this. The dotted line indicates the bottom of the box.

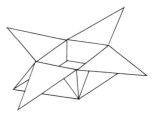

15. Very gently, tuck your index finger into the center of the box and at the same time, lift the points of the star. The box should fall into shape. You will need to coax the crease along the bottom fold line to make its edges sharp.

Balloon

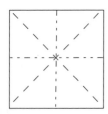

1. Make mountain folds, edge to edge, and valley folds, corner to corner.

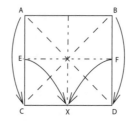

2. Mountain-fold the E and F edges, bringing A down to C and B down to D.

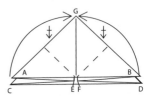

3. Fold A and B up to G. Repeat behind with C and D.

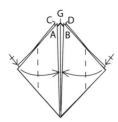

4. Fold in the left and right front corners to meet at the center of the paper. Repeat behind.

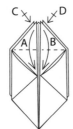

5. Fold down A and B. Repeat behind with C and D.

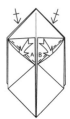

6. Tuck into pockets. Repeat behind.

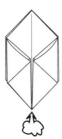

7. Blow air into opening.

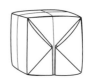

8. The finished Balloon.

1. Valley-fold into a triangle.

2. Valley-fold the triangle from left to right as shown.

3. Turn the paper around so that the single-folded edge (indicated by a broken line) is to the right and the open edges are to the left.

4. Your shape should look like this.

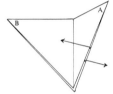

5. Lift up point A and squash fold it down.

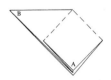

6. Your paper should look like this. Turn the paper over and repeat step 5.

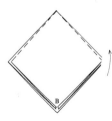

7. Your paper should look like this. Rotate the paper so that the cut edges are pointing to the right.

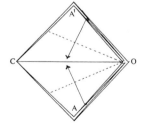

8. Bring the top layer of points A and A1 to the center, making a kite-fold.

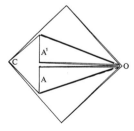

9. Your paper should look like this.

Peacock

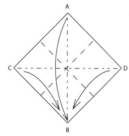

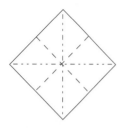

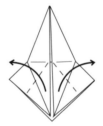

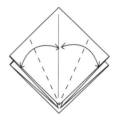

1. Valley-fold in half edge to edge, both ways, and unfold. Mountain-fold corner to corner, both ways, and unfold.

2. Collapse the paper using the creases.

3. Fold and unfold the bottom open edges to the crease.

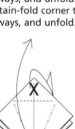

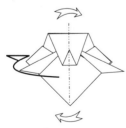

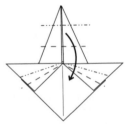

4. Fold top corner "X" behind. Move the bottom corner of the top layer all the way up while folding in the sides. Look at step 5 for the shape.

5. Fold out the bottom corners.

6. Fan-fold the wings. Mountain- and valley-fold for the neck and beak. Look at step 7 for the shape.

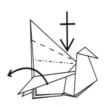

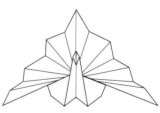

7. Mountain-fold in half. Rotate the paper.

8. Mountain- and valley-fold the tail corner. Pull up the head and open out the wings.

9. The finished Peacock.

Kimono

1. Start with a narrow strip of paper. Fold in half the long way and unfold. Fold up a little bit of the bottom edge.

2. Mountain- and valley-fold, letting the folded margin be taller.

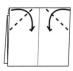

3. Fold over the top corners.

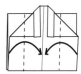

4. Fold in the sides, but not all the way to the center.

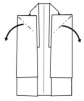

5. Fold out the sleeves, flattening the top corners to form triangles.

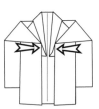

6. Tuck coat edges under the collar. Turn over.

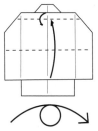

7. Fold down the top edge, then fold up the bottom edge, tucking under the top fold. Turn over.

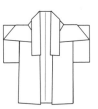

8. The finished Kimono.

Simple Swan

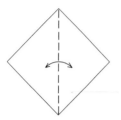

1. Valley-fold diagonally from right to left. Unfold.

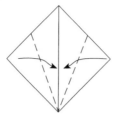

2. Fold each bottom edge of the paper in toward the center fold you made in Step 1.

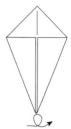

3. Your paper should now look like a kite Turn the paper over.

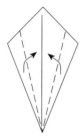

4. Valle-fold each side edge in toward the center once again.

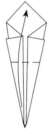

5. Valley-fold the bottom point upward to meet the top point.

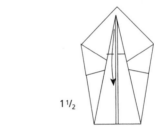

$1^1/_2$

6. Mountain-fold the narrow point approximately $1^1/_2$ inches down.

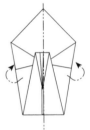

7. Mountain-fold the entire piece in half vertically.

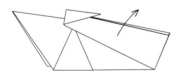

8. Pick up the swan and gently pull upward on the swan's neck (firmly hold the tail section with your other hand), and crease along the base of the neck once the neck is pointing in the 11 o'clock position. This will help the neck remain in position.

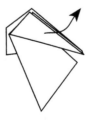

9. Pull the head up slightly and crease to hold in place.

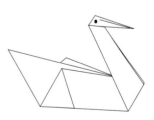

10. The finished Swan.